This photograph was taken by famed photographer Ed Lawrence, known for capturing Thousand Oaks and Westlake Village for decades. The 40-cow tree was shot on the Albertson Ranch, but really represents the scene on any number of ranches in the area, full of trees and cows. (Courtesy of Ed Lawrence Collection, Thousand Oaks Library.)

ON THE COVER: Gene Agdeppa, one of the cowboys on the Albertson Ranch, takes a last look at the beloved ranch where he did most of his work, and bids farewell. The Lone Oak sits below, near the horse's nose in the photograph. The photograph was taken on Pork Chop Hill, on what is now known as Stoneshead Court in Westlake Village. (Courtesy of Ed Lawrence Collection, Thousand Oaks Library.)

IMAGES of America
THOUSAND OAKS AND WESTLAKE VILLAGE

Tricia O'Brien

Copyright © 2017 by Tricia O'Brien
ISBN 978-1-4671-2569-7

Published by Arcadia Publishing
Charleston, South Carolina

Printed in the United States of America

Library of Congress Control Number: 2017942085

For all general information, please contact Arcadia Publishing:
Telephone 843-853-2070
Fax 843-853-0044
E-mail sales@arcadiapublishing.com
For customer service and orders:
Toll-Free 1-888-313-2665

Visit us on the Internet at www.arcadiapublishing.com

To Ed Lawrence.

Contents

Acknowledgments 6
Introduction 7
1. Early Pioneers 9
2. Hollywood in the Country 21
3. Thousand Oaks 37
4. Westlake Village 89

Acknowledgments

I would like to send a special thank-you to photographer Ed Lawrence for sharing his beautiful photographs and stories of Thousand Oaks and Westlake Village to help make this book possible. It has been a pleasure getting to know you. I would also like to thank John L. Notter for all the time he has spent with me sharing his story of how he made the dream of Westlake Village a reality. Jeanette Berard, thank you for your patience, keen eye for detail, and wealth of local knowledge; I couldn't have done this without you. I would also like to thank the Conejo Valley Historical Society at the Stagecoach Inn Museum—in particular, Carol Anderson and Miriam Sprankling—for your time, patience, and guidance as I poured through your files. And thanks go to Jill Lederer for allowing me to invade the archives at the Greater Conejo Valley Chamber of Commerce.

There have been so many people in the community who have helped in many ways to make this book possible, and I am truly grateful to all of you. There were some who went way above and beyond to share their love of this area and give me great support, so I would like to give a shout-out to Diane Krehbiel-Delson, Amy K. Commans, Richard Hus, Judy Sheely, Joe Bowman, Rick Lemmo, the entire Oxford family, Robert Werner, Clint Airey, Tom Chisari, Tony Tromonto, John Novi, and Shannon Woodland.

To my husband, Doug Johnson, and our little rascals Bailey, Sebastian, Harpo, and Ronald, whose love and support keep me going every day, I can't thank you enough. And a huge thank-you to my family and friends for all of your love and support.

INTRODUCTION

While interviewing locals as I did my research for this book, each person, upon hearing the topic, would smile and pause. I could practically see the memories swirl in their minds as they spoke the words, "This is a great place," "It was a great place to grow up," and "There's no place like it." The history of this area and the memories that come with it are almost as plentiful as the oak trees and open spaces that once dominated the area. This book barely scratches the surface of the rich history and good times shared in Thousand Oaks and Westlake Village.

Thousand Oaks and Westlake Village are located in the Conejo Valley in the southeastern part of Ventura County, where it meets the western portion of Los Angeles County. Westlake Village straddles the two counties. The area is approximately 38 miles west of Los Angeles and just the other side of the Santa Monica Mountains from Malibu.

The Chumash Indians were the first to live in what is now called Thousand Oaks and Westlake Village. They were later joined by missionaries and Spanish explorers. Fast forward to 1822, when Capt. Jose de la Guerra y Noriega officially filed El Triunfo Rancho on the map as part of a Mexican land grant. Then, when California became a state in 1850, the area became known as Rancho El Conejo.

Early settlers came because the land was less expensive, and they could have many acres to harvest barley and wheat or raise cattle and sheep. Later, residents flocked to the area as development offered more open space for family homes, good schools, jobs, a safe environment, lots of recreational options, and cleaner air to breathe.

In the 1920s, the Conejo Valley was full of thousands of oak trees, and the area now known as Thousand Oaks had maybe 100 people. These people were tired of being lumped in with the surrounding areas, particularly Camarillo, which was over the grade. They wanted a name for their own city, so a contest was held to name it. Fourteen-year-old Bobby Harrington came up with Thousand Oaks. He won $5 and a little piece of land.

Jungleland really put Thousand Oaks on the map and attracted Hollywood to the country. Movie stars like Clark Gable and others from Los Angeles and the San Fernando Valley, as well as locals, used to go there all the time. The roar of the lions at night was a local lullaby. The animals were working actors, and sometimes escape artists. One day, the Widick family came home from shopping in Oxnard to find escaped monkeys swinging in their trees.

Hollywood fell in love with the Conejo Valley. Many movies and television shows have been filmed here since the silent-film era. The natural beauty and diverse topography allowed one set to transform into numerous unique locations to accommodate the Hollywood imagination without having to actually travel the world. In 1922, *Robin Hood*, starring Douglas Fairbanks, was filmed near the base of the Matthiessen Dam in Hidden Valley. As a result of the film's popularity, the lake and nearby oak grove were renamed Lake Sherwood and Sherwood Forest. *The Last of the Mohicans* was filmed on the Russell Ranch. Many famous people called this area home or visited often to get away from the city and just be themselves. Movie stars like Norma Jean Mortenson

(later known as Marilyn Monroe) lived with Ida Hayes in foster care in Thousand Oaks, and Dean Martin and Sophia Loren had ranches in Hidden Valley, to name a few. Mickey Rooney and the Jackson family had homes on the island of the Westlake Village Lake. Today, many actors, musicians, athletes, writers, and more call this area home, but since they came for the privacy, that is as far as we will go on that topic.

At one point in the early 1960s, Metro-Goldwyn-Mayer (MGM), Fox, and Columbia Pictures were interested in building an enormous studio in Thousand Oaks. The area is approximately 35 miles from downtown Los Angeles. They bought the land, and as a result of the sale, Edwin Janss became the fourth largest stockholder in MGM. The studio was never built, and eventually Amgen went into the space; it is now one of the largest employers in the area.

Thousand Oaks was also known for sheepherders and cowboys. There were acres of open space, wildlife, snakes, and tarantulas. Highway 101 was a two-lane road. Jockey Meade's Plunge and Eddie Cover's Redwood Lodge restaurant were really the only places to go in Thousand Oaks. If people wanted entertainment, they had to go to Hollywood, Santa Barbara, or Oxnard for dinner. San Fernando Valley was the closest shopping, but today, everything is close at hand. Cobb Oxford remembers riding horses with his friends along Thousand Oaks Boulevard, stopping at his dad's shop the Meat Locker and going inside to get a soda or ice cream while the horses stood outside at the hitching post, and then hopping back on and continuing their ride down the boulevard to see who else was out. Conejo Valley Days was something to look forward to every year. The whole town participated, and everyone had a good time.

In the mid-1950s, the Janss Investment Company turned Newbury Park and Thousand Oaks into part of its master-planned community, a vision of creating an all-encompassing place to live and work. In 1964, the city of Thousand Oaks became the first and only incorporated city in the Conejo Valley. By 1968, the plans for Westlake Village became a reality.

Many people thought that the creation of Westlake Village was easy, almost like magic; however, a lot of hard work and imagination went into making this planned community. In October 1881, Andrew Russell outsmarted the competition after overhearing a man bragging about some land he was about to purchase and rode faster than the stagecoach to buy the ranch now known as Westlake Village. In 1925, Russell sold the ranch to William Randolph Hearst, but leased the land for cattle ranching while Hearst searched for the oil he was convinced was located under the land. Unsuccessful in his efforts, Hearst sold the property to Fred Albertson in 1943. Albertson ran a successful cattle ranch and continued to allow the property to be used for television and movie sets. In 1963, American-Hawaiian Steamship Company purchased the land to build a dream community with all the amenities required for ideal living. The Mediterranean weather, free of Los Angeles smog and most of the coastal fog, helped with the dream plan.

Westlake Village was the fastest growing community in California in the 1960s. With the explosive growth, some roads were rerouted or expanded, roads that did not go through were extended, and some were given new names. Ventura Boulevard became Thousand Oaks Boulevard, and Decker Canyon Road became Westlake Boulevard. It was touted as a great place to raise a family and enjoy outdoor activities, which it still is today.

The technology industry is growing roots in the area, and Thousand Oaks Boulevard is set for change again with plans for multiuse buildings that promote live-and-work areas that encourage pedestrian traffic rather than adding more cars to the street. While keeping the integrity of the area and original plan, change still takes place in a positive way out here.

One
EARLY PIONEERS

In the late 1800s, the closest post office was in Ventura. Egbert Newbury noticed that the stagecoach delivering mail passed by his house on its round trip between Ventura and Los Angeles, so he applied to have a post office stop. The request was granted, and as seen here, the area looked like a park, so the stop was named Newbury Park. The tent to the right of the Newbury house was the actual post office. (Courtesy of Conejo Valley Historical Society at the Stagecoach Inn Museum.)

The Whiteside Ranch was located in Hidden Valley. Olney and Ellen Whiteside purchased the land in 1874 and worked it themselves until their son Alexander took over in 1895. Alexander is on the horse closest to the thresher, and his wife, Addie, and one of her sisters are in the horse-drawn buggy beside him, while the threshing machine, carrying six farm workers, is pulled by a large team of horses. Alexander kept the ranch until 1925, when he sold a majority of the property to Maj. Leigh French. The smaller section, the Talley Ranch, was kept longer and eventually was renamed the White Stallion Ranch. (Courtesy of the Thousand Oaks Library.)

The ranch was primarily a dry-farming operation of barley and wheat. They used threshing machines to harvest. Horses and wagons were used to transport the product after harvesting. Most people also raised their own horses for working the land. (Courtesy of Robert Werner.)

After a very quick stint as a gold miner, John Edwards decided that selling supplies to the miners was more profitable. Edwards and Howard Mills bought as much land as they could and soon had acquired over 20,000 acres each; they then sold it off little by little. Edwards owned a home near what is now the Oaks Mall but never lived there himself; however, he cared very much about the area. He leased the land to the Wadleighs, and during the drought of 1877, rather than see the family go bankrupt, Edwards did not accept rent until they were able to sustain themselves again. (Courtesy of Conejo Valley Historical Society at the Stagecoach Inn Museum.)

The Orville Austin Wadleigh family lived in the Conejo Valley for 40 years. They leased land from John Edwards to raise sheep and grow wheat. This is the Wadleigh crew, who helped harvest the wheat and also helped other ranchers cut their grain with Wadleigh's big harvester around 1892. (Courtesy of Conejo Valley Historical Society at the Stagecoach Inn Museum.)

What is now known as the Stagecoach Inn Museum had many names, owners, and uses. It was first owned by James Hammell when it was the Grand Union Hotel, and then by J.B. Redfield when the name was changed to Hammell House. Cecil and Cicelie Haigh, shown here, followed in ownership and changed the name to the Conejo Hotel at Timberville, then two years later to Big Hotel. They built their own private house behind the hotel. Cecil raised grain. He and Cicelie were cousins and had four children. The inn then turned into apartments for various renters. Simon and Ethel Hays eventually took ownership, and under them, renters used it as Robling Military Academy, Chicken and Steak House, and Tantony gift shop. The Hays son Allen took ownership until 1968, when the Conejo Recreation Park District took over; today it is open to the public as a museum. (Both, courtesy of Conejo Valley Historical Society at the Stagecoach Inn Museum.)

The Grand Union Hotel opened in 1876 and primarily served as a resting point for those traveling between Los Angeles and Santa Barbara. Over the years, the name changed to the Stagecoach Inn, and it continued to evolve with the times and was used as a tearoom, restaurant, post office, church, and even a military school. In the 1960s, it was relocated to accommodate a new highway, and in 1970, it burned to the ground but was rebuilt. It is now a museum, and is listed in the National Register of Historic Places and is a California and Ventura County Historical Landmark. (Courtesy of Conejo Valley Historical Society at the Stagecoach Inn Museum.)

This photograph offers a peek into how people dressed and traveled in the Conejo Valley in the 1890s. The Grand Union Hotel is in the background, and laundry flaps in the breeze on the right. (Courtesy of Conejo Valley Historical Society at the Stagecoach Inn Museum.)

Caspar Borchard stands on the left with seven of his eight children in front of the family house. He ran a very productive wheat farm and raised goats and his own horses to pull the farm equipment. He and others established the Timber School District so the children in the area would not have to travel to learn. In 1918, Borchard retired and split the ranch between his eight children. (Courtesy of Conejo Valley Historical Society at the Stagecoach Inn Museum.)

Caspar Borchard and his family and friends share a picnic in 1910. The Borchards owned about 8,000 acres in the Conejo Valley. The family started farming north of Conejo Valley but decided to expand, as land was less expensive in this area. (Courtesy of Conejo Valley Historical Society at the Stagecoach Inn Museum.)

John Riley Kelley, a rancher, arrived in the Conejo Valley in the late 1880s. He purchased 100 acres at Michael Drive, across from the Borchard House. His son Silas inherited the property with the cattle, hogs, and wheat. Silas married Rosa Borchard and eventually inherited 700 acres from his father-in-law. This photograph shows Silas, Rosa, and their eight children. (Courtesy of Conejo Valley Historical Society at the Stagecoach Inn Museum.)

Classes began in 1889 at the Timber School, the first school in the western Conejo Valley after the Conejo School was deemed too far for the new settlers. It was located on the southeast corner of Kelley and Newbury Roads in Newbury Park. Cecil Haigh sold two acres of his land to accommodate the one-room schoolhouse. The Haighs, the Hunts, the Borchards, and the Wadleighs were the families who led the new school district. Children from nearby farms either walked, rode their horse, or traveled in a wagon to get to the school. The bell in the tower called the children to class, recess, and lunch. It was considered an honor to be selected to ring the bell. (Courtesy of Conejo Valley Historical Society at the Stagecoach Inn Museum.)

A farmer harvests along a field where Highway 101 is now. The Stagecoach Inn is in the distance at right. (Courtesy of Conejo Valley Historical Society at the Stagecoach Inn Museum.)

Reba Hays Jeffries was the granddaughter of Cecil Haigh, who once owned the Conejo Hotel at Timberville, now known as the Stagecoach Inn in Newbury Park. Reba was a businesswoman and real estate developer. She was the first female president of the Newbury Park Chamber of Commerce. Shown here are Simon Hays with his daughter Reba sitting on a cow. Simon and his wife, Ethel, lived near the inn, and they took it over from 1926 until 1957, when their son H. Allen Hays became the owner. (Courtesy of Conejo Valley Historical Society at the Stagecoach Inn Museum.)

Richard Orville Hunt and his wife, Mary Jane Brown Hunt, had a house across from where the Oaks Mall now stands. In this photograph, Orville is sitting near Lake Matthiessen, which later became Lake Sherwood. (Courtesy of Conejo Valley Historical Society at the Stagecoach Inn Museum.)

In 1881, Andrew Russell took a stagecoach to look at some land that was for sale in the Conejo Valley. The man seated next to him was bragging about a piece of land that he was going to buy. When Russell realized that the man was talking about the same piece of land he was interested in, he hopped off the stagecoach, found the fastest horse available, and rode like the wind. The salesman was waiting for the other buyer, so Russell asked for a tour. He liked what he saw, so he offered the salesman a gold piece worth $20 as down payment, and the property was sold minutes before the stagecoach arrived. The ranch was called the Triunfo Ranch, owned by Howard Mills until the bank took over. Russell renamed it Conejo Ranch, but many locals just called it Russell Ranch. Shown here are Andrew Russell with his grandson Joe Russell Jr. sitting on the horse. (Courtesy of Conejo Valley Historical Society at the Stagecoach Inn Museum.)

The Crawley family bought the Newbury property, which was next door to the Russell family. The two families were extremely close. Pictured in 1918 are, from left to right, Alex Crawley, Patricia Russell, Joe Russell Jr., Margaret Russell, and Charlotte Crawley. (Courtesy of Conejo Valley Historical Society at the Stagecoach Inn Museum.)

Abigail Russell was very pleased to see that a schoolhouse already existed on the property that her husband had purchased. The Triunfo School, a one-room schoolhouse, was the original school in the area. This picture shows the structure that was moved to this location as the school's second building. The Russells funded the school and the teachers and insisted that the children of the ranch workers attend. Abigail actually preferred to hire workers with children. She changed the name to the Conejo Valley School and established a school district. The school would later move to a new location with a new Spanish-style building. When that exceeded its capacity, yet another school was built. (Local History Collection, courtesy of the Thousand Oaks Library.)

In 1934, there was a barbeque in Westlake Village on what is today Lindero Canyon Road near Costco, to celebrate Prohibition being repealed. They served 11 types of beef, and Acme Beer sponsored a 90-foot-long bar with a keg of beer every 10 feet. (Courtesy of the Thousand Oaks Library.)

This is an old Newbury Park gas station that also served as a grocery store, feed store, post office, and allegedly, a library. The Stagecoach Inn is visible in the background of this photograph, taken in either the late 1920s or early 1930s. (Courtesy of the Thousand Oaks Library.)

Two

HOLLYWOOD IN THE COUNTRY

This view looking west is of Russell Ranch, with Russell Ranch buildings barely visible at upper right below the mountains. The arroyos were a Hollywood favorite because they hid the existing buildings and any camera, lighting, or prop equipment required during filming. (Courtesy of Ed Lawrence Collection, Thousand Oaks Library.)

Louie Goebel worked as a meat cutter for Carl Laemmle in the private zoo at Universal Studios. When Laemmle decided to get rid of animals, primarily lions, Louie bought them and moved them to Thousand Oaks. It was first known as Goebel's Lion Farm, but when Disneyland came into existence, the name was officially changed to Jungleland. Many of the first residents of Thousand Oaks lived near the animal park and could hear the roar of the lions as if they were in their own backyard. (Courtesy of Ed Lawrence Collection, Thousand Oaks Library.)

Louie Goebel is sitting on the hood of a Chevrolet coupe with Caesar the lion. Caesar started working in films at a very young age, which meant that Goebel had to drive him back and forth to the studio. The cub liked riding in the car and especially liked hanging his head out the window. At the end of the day, he did not like leaving the car. Eventually, he grew too big to be riding around in the coupe, but he did not lose his love of the Chevrolet. (Courtesy of Conejo Valley Historical Society at the Stagecoach Inn Museum.)

Louis Goebel sold Goebel's Lion Farm to Trader Horne and Bill Richards, who changed the name to World Jungle Compound. They ran the theme park and training facility from 1946 to 1955. Animals were trained to work in movies and television. This was a major attraction and brought many people to Thousand Oaks to see the wild animals live and up close. This souvenir program provided facts about wild animals in motion pictures, featured the staff and which animals they specialized in training, and a detailed map to all of the animals, including Leo the MGM lion and Tamba the chimpanzee from *Bedtime for Bonzo*, as well as information about the studios that hired the animals. (Courtesy of Judy Widick Sheely.)

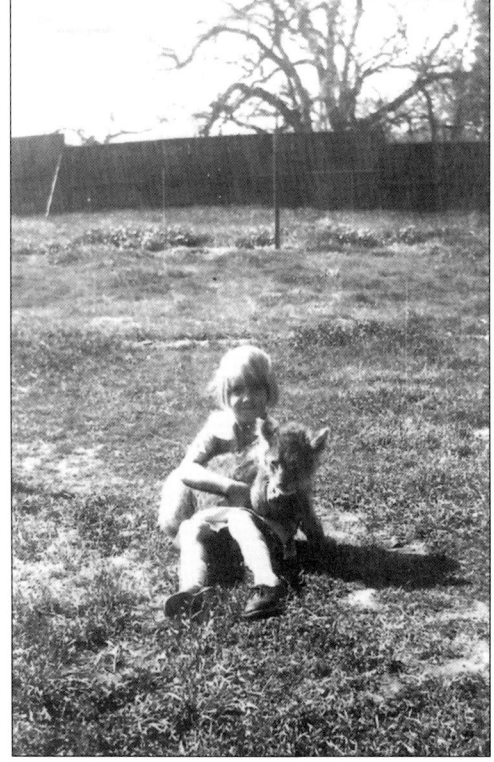

This is Maxine Fields, later Widick, holding a baby tiger from Jungleland. Being friends with the owner gave her special access. In the early days, children used to hop the fences and run through the camel enclosures, then hop another fence to get into Jungleland. Maxine was the first baby born in Thousand Oaks, on May 15, 1923, after the city was officially named. (Courtesy of Judy Widick Sheely.)

Maj. Leigh and Elinore French of Hidden Valley catered parties for a lot of movie sets, since so many films were made in the area. They are shown here with Hoot Gibson (right), who starred in silent films and some of the first talking Western films. (Courtesy of Ed Lawrence Collection, Thousand Oaks Library.)

In 1938, *Wuthering Heights* was filmed on the Olsen Ranch near where California Lutheran University is today. In 1939, the film won the New York Critics Award for best film, and in 1940, it received eight Academy Award nominations. Gregg Toland won an Oscar for best cinematography in the black-and-white category. (Photograph by Herb Noseworthy, courtesy of the Thousand Oaks Library.)

Academy Award–winning actor Walter Brennan lived on a ranch in Moorpark. Here, he is holding a copy of a Norman Rockwell painting of himself in character; the original hangs in the National Cowboy Hall of Fame. (Photograph by Bob Pool, News Chronicle Collection, courtesy of the Thousand Oaks Library.)

This shot shows several vehicles lined up and ready for their part in the television series *Combat!* Part of a Western set is also visible in the background. This photograph was taken in the mid-1960s in North Ranch before the area was developed into luxury homes and a golf course. (Photograph by Herb Noseworthy, courtesy of the Thousand Oaks Library.)

Cowboy Gerald Davis, foreman of a ranch in Hidden Valley, rides through a *Gunsmoke* set in Wildwood Park in April 1965. The two ridges in the background, named Mountclef, are a recognizable trademark of Wildwood. Today, the dirt road is Avenida de los Arboles in Thousand Oaks. Gerald Davis was in a national Campbell's Soup commercial and made enough money from that to purchase a ranch in Magazine, Arkansas. (Courtesy of Ed Lawrence Collection, Thousand Oaks Library.)

Above is another view looking down from Mountclef onto the green land planted with barley. The ranchers still used the old threshing machines to cut the barley. Elvis Presley was here while filming *Flaming Star*. Below is the same view in 1997, after development had taken charge and expanded with many new homes and new trees. (Both, courtesy of Ed Lawrence Collection, Thousand Oaks Library.)

Actor James Arness relaxes in the shade between takes on the *Gunsmoke* set. This was practically a home away from home for the actor. (Photograph by Herb Noseworthy, courtesy of the Thousand Oaks Library.)

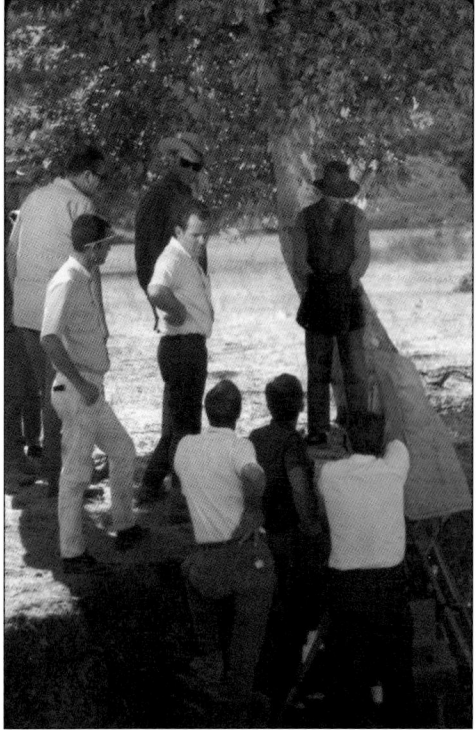

The weekly television series *Gunsmoke* was shot on the Westlake Village property known as the Albertson Ranch and on the Conejo Ranch property in Thousand Oaks. In this photograph, James Arness (upper right, with hat), who played Marshal Matt Dillon for 20 years, is with the camera crew discussing how to film a scene. (Courtesy of Ed Lawrence Collection, Thousand Oaks Library.)

This is the set for *Gunsmoke* and *Texas Across the River*, starring Dean Martin, who lived in Hidden Valley. The location is in North Ranch, which is now covered in luxury homes. (Courtesy of Ed Lawrence Collection, Thousand Oaks Library.)

Even after development, the old set used in productions such as *Gunsmoke* and *Texas Across the River* stood in remembrance. In 1969, the Westlake Inter-Am held a motocross race with a fun route that ran down the streets of the Western set and even went through the barn, thrilling motorcycle enthusiasts in the area. (Courtesy of Ed Lawrence Collection, Thousand Oaks Library.)

This is Skelton Canyon Road, known today as Westlake Boulevard. About a quarter mile north of where this photograph was taken was the spot where Bonnie and Clyde met their demise in the 1967 movie *Bonnie and Clyde*. (Courtesy of Ed Lawrence Collection, Thousand Oaks Library.)

Cattle are grazing along Decker Canyon Road before it became Westlake Boulevard. This group of cattle was often used in the *Rawhide* television series, so the ranchers kept the horns on them and did not put these "actors" into the regular cattle trade corral. (Courtesy of Ed Lawrence Collection, Thousand Oaks Library.)

Clint Eastwood is pictured on the set of *Rawhide*. Many of the episodes were shot on the Albertson Ranch. *Rawhide* became a hit series and really launched Eastwood's career. (Courtesy of Ed Lawrence Collection, Thousand Oaks Library.)

Actress Eve Arden, her husband actor Brooks West, and their family share a meal at Boccaccio's Restaurant at the Landing. Arden's children attended Conejo School and participated in the Pets and Hobbies Show, where Eve was always in attendance but kept a low profile, allowing the children to take the spotlight. (Courtesy of Ed Lawrence Collection, Thousand Oaks Library.)

Even after development, Westlake Village and Thousand Oaks were still popular locations for filming movies and television. Here is Efrem Zimbalist Jr. on the set of the television series *The F.B.I.*, filmed at the Landing along the lake in Westlake Village. (Courtesy of Ed Lawrence Collection, Thousand Oaks Library.)

This is part of the biggest movie set Columbia Pictures ever built. The wall is part of a Japanese war prison for the 1965 World War II movie *King Rat*, George Segal's first big movie. The fake cemetery was located in the gully where the wall of the Westlake Lake Dam would eventually be built. The film was nominated for two Academy Awards for cinematography and art direction. (Both, courtesy of Ed Lawrence Collection, Thousand Oaks Library.)

The television series *Switch* starred Eddie Albert and Robert Wagner, shown here playing a retired cop and an ex-con, respectively, now working together to solve crimes. An episode was filmed in Westlake Village during the first season of the show. Wagner lived in Hidden Valley at the time. (Courtesy of Thom Schillinger.)

The television series *Charlie's Angels* filmed two episodes in Westlake Village: "The Killing Kind," which aired in 1976, and "Angel in a Box," which aired in 1979. In this photograph, Farrah Fawcett and Kate Jackson sign autographs for excited fans in the neighborhood. (Courtesy of Thom Schillinger.)

A segment of the television show *Marcus Welby, M.D.* was written by Westlake Village resident David Moessinger and filmed in Newbury Park. Many excited children watched as (from left to right) Robert Young, Pat Crowley, and George Grizzard rehearsed and filmed the episode right in front of them. (News Chronicle Collection, courtesy of the Thousand Oaks Library.)

To the delight of neighborhood children, the popular television series *Mannix* filmed in Westlake Village. This photograph of actor Mike Connors (in suit) and children hoping for an autograph was taken in 1971 at Brentford and Devonshire Avenues in the Foxmoor area. (Photograph by Janelle Tyler, News Chronicle Collection, courtesy of the Thousand Oaks Library.)

Harold Livingston was a major in the US Army Air Forces during World War II and in the US Air Force during the Korean War. He also helped start the Israeli air force and flew in the 1948 Arab-Israeli War. Nancy Spielberg featured him as one of the volunteer Israeli pilots in her documentary *Above and Beyond*. Livingston became a writer in Hollywood and went on to write television episodes, film screenplays, and several novels. His most famous film screenplay is *Star Trek: The Motion Picture*. As a novelist, he won the Houghton Mifflin Literary Fellowship Award for his debut novel *The Coasts of the Earth*. Livingston half-jokingly considers writing his curse, saying, "I *must* write, I cannot help myself." To get away from the hustle and bustle of Hollywood, he and his wife Lois moved to tranquil Westlake Village. Here, Livingston (right) hangs out with William Shatner on the *Star Trek* set. (Courtesy of Harold Livingston.)

Three
THOUSAND OAKS

It may be hard to imagine today, but sheep on Thousand Oaks Boulevard were not an uncommon sight in the past. This photograph shows sheep being herded on Thousand Oaks Boulevard and Moorpark Road in June 1965. The little lamb walking with the dogs actually thought he was a dog. (Courtesy of Ed Lawrence Collection, Thousand Oaks Library.)

This is the Rancho Conejo Airport, also known as the Janss Airport, on the left, in 1949. The road at center is Ventura Boulevard before the highway split through. On the bottom right is the Meadowbrook Plunge, as well as the Jockey Meade's Kentucky Derby Inn and other businesses, before Moorpark Road. Mount Conejo is visible at top, as are the Janss silos at top right. (Courtesy of Thousand Oaks Library.)

Here is an aerial photograph of the old Conejo Ranch, also known as the Janss Ranch, taken in 1967. Thousand Oaks Boulevard, just after being straightened, snakes along to the left of Highway 101. Moorpark Road cuts across the center. Highway 23 had not been constructed, and Hillcrest Drive did not have a clear path yet. (Courtesy of Ed Lawrence Collection, Thousand Oaks Library.)

This is the Janss Mall, which opened in 1961 on Moorpark Road and Hillcrest Drive, which was originally known as Village Lane. It was the only major shopping center until the Oaks Mall was built. After a major remodel, it was renamed the Janss Marketplace. (Courtesy of Ed Lawrence Collection, Thousand Oaks Library.)

Brothers William "Bill" Janss (left) and Edwin "Ed" Janss Jr. (right) were responsible for the boom in growth in the Conejo Valley. They owned a majority of the Conejo Valley land from California Lutheran University down to the other side of Highway 101, where the golf course is now. They started to sell to developers in 1958, and the area took off with housing, new businesses, and jobs. (Courtesy of the Thousand Oaks Library.)

Don Meade, the oldest of the eight Meade children, won the Kentucky Derby in 1933. He purchased a business called Barber's Camp for his parents that had a restaurant, gas pump, and a house with six cabins. They later renamed it Jockey Meade's Kentucky Derby Inn. This was the place to be. In this photograph, Charlotte and Arthur Meade are on the right, with Charlotte's family, the O'Neals, lined up behind them in front of the inn in the late 1930s. (Courtesy of Conejo Valley Historical Society at the Stagecoach Inn Museum.)

After World War II, the Meade boys—Ray, Wally, Harvey and Bobby—decided to turn the family property into a place that could be enjoyed by all. There was a swimming pool, picnic area, snack bar, and a place for dancing to the jukebox. It was named the Meadowbrook Plunge, but locals called it Jockey Meade's. People came from all over to enjoy themselves. (Courtesy of Conejo Valley Historical Society at the Stagecoach Inn Museum.)

Marshall Fields serves as lifeguard at Jockey Meade's while a number of neighborhood families enjoy a day at the pool. There was not a whole lot to do in the neighborhood, so the plunge provided hours of entertainment and recreation for families. The property had a jukebox so it could hold dances for the teens. (Courtesy of Judy Widick Sheely.)

The Tom & Warren Chevron station, owned by Tom Fields and his father-in-law Warren Widick, was across from the Conejo Airport and next door to Jockey Meade's. All the neighborhood children wanted their parents to go to this station because Tom Fields let them have a piece of the popular Tom's peanut butter log candy as a treat. (Courtesy of Judy Widick Sheely.)

Warren Widick is teaching his young son Tommy how to pump gas. Warren and his father owned the station from 1945 to 1956, when it was sold to Dave East. (Courtesy of Judy Widick Sheely.)

Allegra Cronk was known around town for her 1928 Desoto coupe, shown parked in front of the Community Church. Cronk was a beloved member of the community. She lived at 580 Erbes Road at what she dubbed "Sunshine Acre." She was the Sunday school superintendent and was involved in numerous groups such as the PTA, chamber of commerce, and youth programs; she was also a local columnist. (Courtesy of Judy Widick Sheely.)

The Community Church was primarily built by the Weinkes and the Fields. Here, 24 members of the junior choir, directed by Ursula Stoddard, pose during their weekly practice session. From left to right are (first row) Susan Dester, Mary Ogburn, Amy Ogburn, Sarah Ogburn, Sandra Rockwell, and Karen Eby; (second row) Marjorie Fields, Lana Widick, Gary Pruett, Billy Bradley, Hank Hall, Tommy Widick, Charles Morris, Bryan McNutt, Lennie Christopher, and Susanne Weiss; (third row) Linda Pruett, Deanna Maurer, Jettia Billee Loy, Cassie Burt, Maudie Lee Christopher, Marsha Fields, and Paulette McReynolds. (Courtesy of Judy Widick Sheely.)

The Running Springs Ranch barn was a popular place, with wooden floors for dances. In the early 1950s, the Janss brothers purchased the land and later sold it for development. The barn is no longer in existence. (Courtesy of Ed Lawrence Collection, Thousand Oaks Library.)

In this June 1965 photograph, sheep graze near Lynn and Janss Roads. Wildwood is visible in the background. (Courtesy of Ed Lawrence Collection, Thousand Oaks Library.)

Builder William Lyon and the Janss Corporation joined forces to make recreational improvements to Wildwood Park. Shown here is the beginning of the log fort known as Fort Wildwood, situated at the opening of the park near Avenida De Los Arboles and Lynn Road. (Photograph by Frank Knight, News Chronicle Collection, courtesy of the Thousand Oaks Library.)

The Oakdale Inn dance hall and saloon was only a dance hall and saloon for six months, as it had to close due to too much fighting. The Oakdale Market opened instead, and became the place to go for food shopping. The market also housed the post office for a short time, until it moved across the street. (Courtesy of Judy Widick Sheely.)

Shown here is the beginning of construction for California State Route 23 in Thousand Oaks. It was originally considered the "freeway to nowhere." (Photograph by Herb Noseworthy, News Chronicle Collection, courtesy of the Thousand Oaks Library.)

Dupar's was the place to go to meet a friend. It was famous for its blueberry cheese pie. The Stagecoach bus line that went to the airport stopped here to pick up passengers. (Courtesy of Ed Lawrence Collection, Thousand Oaks Library.)

Nixon's was the general store in the area. Owned by Tom and Ethel Nixon, residents could get much of what they needed here. Big shopping was done in Oxnard, Ventura, or Los Angeles. Ethel Nixon was the first librarian in the Conejo Valley, so at one point, the store also served as a library. (Courtesy of the Local History Collection, Thousand Oaks Library.)

This is an early 1900s high school production of *Hamlet*. From left to right are Agnes Sheaf, Ethel Forbes (later Nixon), Frances Young, Agnes Hillebrecht, Larena Rippe, and Corine Saunders. Ethel (Forbes) Nixon was a longtime Conejo Valley resident, born in 1885, died in 1986; she was the Thousand Oaks librarian from 1948 to 1962. (Courtesy of the Local History Collection, Thousand Oaks Library.)

Donnelly's Garage on Ventura Boulevard offered a variety of automobile services. This photograph was taken in approximately 1925. (Courtesy of Judy Widick Sheely.)

Bill and Emm's Coffee Shop was on Thousand Oaks Boulevard, near where the auto mall is today. It had a walk-up counter for those on the go, a picnic table on the side, and a popcorn machine out front. The name was later changed to Dixon's Coffee Shop, although the Dixons did not own it for very long. It later became a store popular with teens looking to purchase 45 rpm records. (Courtesy of Judy Widick Sheely.)

Bruce Oxford was born in North Dakota in 1931; he then moved to Kansas, and in 1948, hitched a ride with relatives to California. A relative, Carl Isom, introduced him to a butcher knife at 16, and at age 17, he got his first job cutting meat at the Oakdale Market. After a stint in the Marines, he returned, and in 1960 opened the Thousand Oaks Meat Locker and Butcher Shop. Oxford not only knew the business well, he sincerely liked his clients and developed long-lasting relationships. People relied on him. Folks with ranches needed his services, and since freezers were not in homes yet, the meat locker allowed people to store food for their families. He also provided quality, healthy meat for customers who did not have their own food source. (Courtesy of the Oxford family.)

Celebrities such as Slim Pickens, Michael Landon, Donna Summers, Richard Widmark, Don Henley, and Rex Allen, just to name a few, were regulars at the Thousand Oaks Meat Locker and Butcher Shop. A portion of the star-studded film *Walk on the Wild Side* was filmed there. Ronald Reagan owned a ranch in the area and counted on Oxford for help with his meat. When Reagan became president, his security would not let him eat his own beef, but he still visited his friend Bruce and would gift the meat to family and friends. (Courtesy of the Oxford family.)

When Annette Root was 16, she would ride her horse to the Oakdale Market, tie it to the hitching post, and go in to see Bruce Oxford, who, in 1952, became her husband. In the Oxford family, no one got away from working; daughter Kimberly remembers having to work to earn hay for her horse. Many of the neighborhood kids worked there, too. Here, Annette is getting into the Halloween spirit with dry ice in her cauldron. (Courtesy of the Oxford family.)

Cobb Oxford, owner Bruce's son, grew up with the meat locker. His father taught him the skills he needed, so by the time he was 15, not even old enough to drive the truck, he was taking on his own clients at their ranches and expertly executing the entire process. He has grown with the times by expanding into the restaurant business, and is now one of the last original businesses still around. (Courtesy of the Oxford family.)

Tom Fields is wearing the top hat as he plays the judge at the 1951 Stagecoach Days, held at the Conejo Valley Airport. For crimes such as "no whiskers," punishments ranged from some time in the clink to a dunk in the trough. Funds raised helped community projects. (Courtesy of Judy Widick Sheely.)

In this photograph, Marshall Fields gets dunked as a consequence of having a crummy beard in the "whiskeroo" contest. Even being related to the judge could not save him from punishment. Stagecoach Days replaced Circus Days and later morphed into Conejo Valley Days. (Courtesy of Judy Widick Sheely.)

Here is an aerial view of the Conejo Valley Days carnival and rodeo in 1962. Everyone participated in this event. Moorpark Road is in the foreground, and the carnival is on a portion of the Janss Mall parking lot. What is not clearly visible is a sign at bottom left that claims one can move into a home in Thousand Oaks for $195 down. (Courtesy of Ed Lawrence Collection, Thousand Oaks Library.)

This is the rodeo section of the Conejo Valley Days carnival and rodeo in 1962. Moorpark Road goes through the photograph, and Wilbur Road is off to the left. There has been tremendous growth since this image was captured, and it is hard to imagine now that this area was ever home to a rodeo. The area is now occupied by a car wash and restaurants. (Courtesy of Ed Lawrence Collection, Thousand Oaks Library.)

During Conejo Valley Days in 1962, Montie Montana Jr. is trying to lasso a waitress from the Redwood Lodge. The Redwood Lodge restaurant was on Thousand Oaks Boulevard near Hodencamp Road. Built in 1929, it was a beautiful rustic building with a bar carved out of a single oak tree, with redwood beams on the ceiling. The signature totem pole made with special references to the Kovers family stands in front. (Courtesy of Ed Lawrence Collection, Thousand Oaks Library.)

Every year, Jungleland had an animal represented in the Conejo Valley Days parade. One year, it was the elephants; another year, the camel brigade. This year, it was Leo the lion, the lion who introduces MGM movies. (Courtesy of Ed Lawrence Collection, Thousand Oaks Library.)

Along the parade route of Conejo Valley Days, visitors had to take cover as Jack "Doc" McGrath passed by. He worked for Thousand Oaks Liquors and was a fixture in the parade. Veteran parade goers were prepared for Doc, but newcomers got a bit of a surprise. (Courtesy of Ed Lawrence Collection, Thousand Oaks Library.)

Actor Joel McCrea stands in the chariot, with his friend Belle Holloway in the center of the photograph, surrounded by neighborhood children. McCrea appeared in over 90 films. He purchased property in the Conejo Valley in 1933 and later donated several hundred acres to be used for the YMCA in Thousand Oaks. He claimed that Belle Holloway was the strongest woman he ever met. Her family owned Holloway's Dairy. She remembers having to drive the truck down the grade to Camarillo with the lights out during World War II. She also had a horse ambulance and a hauling company, in which she drove horses to and from horse shows and races for celebrities. (Courtesy of Ed Lawrence Collection, Thousand Oaks Library.)

This was the view coming into Newbury Park from over the Conejo grade in 1963. There was not much there yet, except for one of the first aerospace companies, Tally Corporation, which is off to the right. (Courtesy of Ed Lawrence Collection, Thousand Oaks Library)

This is how drivers used to come into Thousand Oaks prior to the Westlake overpass. The road to the left is Thousand Oaks Boulevard, previously known as Ventura Boulevard. This is the point called "the Triangle," where Highway 101, Decker Road, and Thousand Oaks Boulevard met. This photograph was taken in 1963, facing northwest toward the snowcapped Topa Topa Mountains. (Courtesy of Ed Lawrence Collection, Thousand Oaks Library.)

Here is an overview of Thousand Oaks before Highway 23 was built. Thousand Oaks High School is at center right, with Park Oaks and Ladera on the left. (Ed Lawrence Collection, courtesy of the Thousand Oaks Library.)

In 1937, when Donna Fargo was 19 years old, she rode a horse down Broadway Street in Los Angeles dressed as Lady Godiva to promote the movie *Nothing Sacred*. Fargo thought she was going to be a movie star; the only problem was, she could not act. However, she was quite athletic, so she became a stuntwoman instead. Fargo was the actual person who fell down the stairs in *Gone with the Wind* when Scarlett O'Hara took her big tumble. She hurt her back while filming this scene, ending her career. (Courtesy of Conejo Valley Historical Society at the Stagecoach Inn Museum.)

Donna Fargo, with Lois Lardon, went on to own Venture Publications, specializing in the *Conejo Valley Business Directory*. Fargo was quite well known for her directory. She knew everyone in the community, cared about the residents, and was a huge supporter and promoter of Thousand Oaks. (Courtesy of Conejo Valley Historical Society at the Stagecoach Inn Museum.)

In 1960, Jungleland's center stage featured a beauty contest held for Honorary Mayors Day. This photograph shows the 22 contestants competing in the swimsuit portion of the event. In 1965, Honorary Mayors Day became Conejo Valley Days. (Photograph by Frank Knight, Local History Collection, courtesy of the Thousand Oaks Library.)

In 1961, Francine Herack became Miss Thousand Oaks. She is shown here as the grand marshal of the Conejo Valley Days parade. Herack went on to become the first Miss California USA from Thousand Oaks and was the fourth runner up in the Miss USA pageant. It wasn't until 1980 that a Thousand Oaks contestant held the Miss California USA title again, when Kari Lloyd took the crown, followed by Cynthia Kerby of Westlake Village in 1981 and Suzanne DeWames of Thousand Oaks in 1982. In 2010, Nicole Johnson of Westlake Village was the next local woman to take the crown. (Photograph by Frank Knight, News Chronicle Collection, courtesy of Thousand Oaks Library.)

Nick Costa brought his sheep from the San Fernando Valley out to Thousand Oaks to graze. Most of the sheepherders were from the Basque country in Spain, with a few from Mexico. They had to move the sheep from the hills south of Highway 101 early Sunday morning, as that was the only time they were allowed to move through town and not interfere with traffic. In this photograph, they are moving the sheep under the Highway 101 underpass on Moorpark Road. (Courtesy of Ed Lawrence Collection, Thousand Oaks Library.)

This is Francisco, a shepherd from Mexico, sitting on the McCrea Ranch near the Norwegian Grade, serenading his trusty dogs and a little lamb who thinks he is a dog. The lamb was part of Nick Costa's flock, but he would not stay with the rest of the flock. The lamb slept and ate with the dogs and herded the sheep. The lamb eventually became the star of a children's book by Ed Lawrence, titled *The Lamb That Wanted to Be a Dog*. (Courtesy of Ed Lawrence Collection, Thousand Oaks Library.)

Shown here is Juan Vasquez, the oldest sheep herder in the area. When this photograph was taken, the crew was shearing sheep in Newbury Park, and Juan was the tallyman, with his signature pencil in his hat. (Courtesy of Ed Lawrence Collection, Thousand Oaks Library.)

Even after development started and businesses came into the area, sheep still grazed nearby. After going under the highway, the sheep would then pass by the Conejo Village Theatre, heading toward Lynn Road, which was simply a dirt road in 1965. Herders tried to keep the sheep on one type of grass to avoid getting kinks in the wool, thereby increasing the quality. (Courtesy of Ed Lawrence Collection, Thousand Oaks Library.)

This early 1958 view of Moorpark Road looks south toward the mountains, with Highway 101 in the center. The building at left is the Shell pumping station. Today, Thousand Oaks High School sits on the right side of the road next to where the truck is in the image. This is also the first picture that famed local photographer Ed Lawrence took of the Conejo Valley. (Courtesy of Ed Lawrence Collection, Thousand Oaks Library.)

Pictured here is the Lancer Band of Thousand Oaks High School and their new band teacher, Dave Wheeler, in 1968. The band, a popular part of the Conejo Valley Days parade, has a long history of success and is known as one of the best high school bands in California; they have received numerous awards. (News Chronicle Collection, courtesy of the Thousand Oaks Library.)

This is an aerial view of Thousand Oaks High School in 1972. The school opened in 1962 on Moorpark Road. (Photograph by Frank Knight, courtesy of the Thousand Oaks Library.)

Sheepherders guide their flock across the road after coming over the Borchard overpass from Newbury Park into the Rancho Conejo Industrial Park. (Courtesy of Ed Lawrence Collection, Thousand Oaks Library.)

At lower right in this photograph, the bank still stands, but now other businesses have joined it and are covering the grazing fields. (Courtesy of Ed Lawrence Collection, Thousand Oaks Library.)

Even more growth has taken place. Amgen Inc. has now moved its headquarters in and has taken residence over a large portion of this neighborhood. Amgen is a biopharmaceutical company and one of the largest employers in the Conejo Valley. (Courtesy of Ed Lawrence Collection, Thousand Oaks Library.)

Dick and Doris Hus were honored for their community contributions and named Don and Dona Triunfo at the Triunfo Ball in the spring of 1969. Each year, starting in 1965, the Conejo Valley Historical Society honors two community volunteers—a man and a woman—for their contribution in making Conejo Valley a better place to live. (Courtesy of Richard Hus.)

This is Newbury Park between Borchard and Ventu Park Roads. The drive-in theater is visible near the center, to the right of the freeway in the lighter, open patch of land. (Courtesy of Ed Lawrence Collection, Thousand Oaks Library.)

Here is a closer look at the Thousand Oaks Drive-in movie theater that faced away from Highway 101. *Risky Business* and *Public School* were the last movies shown before the theater closed for good. (Photograph by Scott Harrison, News Chronicle Collection, courtesy of the Thousand Oaks Library.)

Here is a later picture of the Stagecoach Inn from the early pioneer days shown in chapter one. The highway department wanted to tear it down to make room for the Ventu overpass off of Highway 101. The residents of Thousand Oaks did not want to see that happen, so they formed the Conejo Valley Historical Society and raised funds to have the building relocated. (Courtesy of Ed Lawrence Collection, Thousand Oaks Library.)

The project to move the Stagecoach Inn about a quarter mile away is in motion. (Courtesy of Ed Lawrence Collection, Thousand Oaks Library.)

In 1970, tragedy struck, and the Stagecoach Inn burnt to the ground. It is still a mystery as to how the fire started. A replica was built and is still in use as the Stagecoach Inn Museum. (Courtesy of Ed Lawrence Collection, Thousand Oaks Library.)

In 1964, Eichler homes are just starting to be built on the old Janss Horse Farm. Lynn Road is still dirt but getting prepared for paving, while on Camino Manzanas both A-frame and sloped-roof mid-century modern homes, inspired by Frank Lloyd Wright and built by Joseph Eichler, have begun to take shape. Over 100 Eichler homes, designed by two firms, Jones & Emmons and Claude Oakland, would eventually stand in this enclave in the middle of Thousand Oaks. (Photograph by Phil Fahs for Janss Corp., Local History Collection, courtesy of the Thousand Oaks Library.)

Sheep graze in a field where the Los Robles Hospital & Medical Center stands today. (Courtesy of Ed Lawrence Collection, Thousand Oaks Library.)

In 1968, Los Robles Hospital & Medical Center was built on Janss & Lynn Roads in Thousand Oaks. The hospital is constantly earning top honors for its specialized care. Los Robles is proud to be one of the community's most trusted sources for health care and a regional destination for care. (Courtesy of Ed Lawrence Collection, Thousand Oaks Library.)

In September 1968, Ted and Alyce Schuldt moved to Thousand Oaks, and in November, they were among the first patients at Los Robles Hospital. Their son was the first baby born at Los Robles Hospital. (Courtesy of Ed Lawrence Collection, Thousand Oaks Library.)

This is an aerial view of downtown Thousand Oaks. In the upper left, a little bit of Jungleland is visible, with Highway 101 on the left and Thousand Oaks Boulevard to the right. (Courtesy of Ed Lawrence Collection, Thousand Oaks Library.)

From left to right, Thousand Oaks council members and former mayors Dick Hus, Ray Garcia, Chuck Cohen, Carroll Bowen, Ed Jones, Bob Talley, Al Fiore, Dave Irwin, and Larry Horner walk toward the new civic center. The mayor is not elected; instead, the council members rotate into the position each year. Talley was the first mayor. Al Fiore, Ed Jones, and Dick Hus are considered fathers of the community. Fiore was often referred to as "Mr. Thousand Oaks," with at least 30 years on the council; he was great with financial matters and mayor numerous times, making him an icon in the community. Jones was also on the board of supervisors and still serves as president of Conejo Valley Parks and Recreation. Hus was the fourth mayor and is still very active in the community, including as a board member for Many Mansions. (Courtesy of Richard Hus.)

Here is the new Thousand Oaks Civic Arts Plaza under construction on Thousand Oaks Boulevard. This location has gone from animal performances to various live human performances. (Courtesy of the Greater Conejo Valley Chamber of Commerce.)

Here is an aerial view of the Thousand Oaks Civic Arts Plaza in 1994, just after it opened. It is a performing arts center that hosts live performances from well-known musicians, comedians, theater companies, speakers, dance companies, and much more. The Civic Arts Plaza is located on the land that used to house Jungleland. (Local History Collection, courtesy of the Thousand Oaks Library.)

Celebrating breaking ground at 300 Hampshire Road in 1967 for the future home of Skateen roller rink are owner Shannon Woodland, holding the shovel on the left, and councilman Richard Hus on the right. Thousand Oaks architect Don Roberts designed the building, and builder William Coffee made it come to life. Woodland also owned Conejo Valley Electric, so his wife Kay and her sister Shirley Smith managed the rink during the day, and he came in for the evening shift. The Woodlands provided a place for kids to hang out and gave them something to do, but they also ran a tight ship and did not allow any funny business to take place. They even agreed to enforce a haircut dress code to help support the schools, which were having trouble with violators of the code. The popular rink held one or two school parties each week, along with birthday parties, night sessions for the older kids, and lessons during the day. Several skaters went on to national and world meets. (News Chronicle Collection, courtesy of the Thousand Oaks Library.)

Lumber City, a hardware and building materials business, opened its doors on Thousand Oaks Boulevard in 1969. Instead of the traditional ribbon and scissors for the opening ceremony, they used wood and a saw to celebrate the moment. Shown here from left to right are city planning director Barry Eaton, planning commissioners Dick Rosiejka and Walt Wilcox, city councilman Ray Garcia, city manager Glenn Kendall, city building director Gene Pierce, owner Bob Nieman, Conejo Valley Chamber of Commerce president Milton Towle, Beverly Hills Chamber of Commerce president Solly Laub, city attorney Ray Clayton, and Metropolitan Mortgage president Wally Watkins. (News Chronicle Collection, courtesy of the Thousand Oaks Library.)

Robert M. Housley and Ronald W. Grant prepare to test moon rock samples. Astronauts from the Apollo 11 mission brought moon rocks back to earth and sent them to North American Rockwell's Science Center, which was located at 1049 Camino Dos Rios, where Teledyne Scientific & Imaging is now located. Teledyne Technologies acquired Rockwell Scientific Company in 2006. (Photograph by Kent Wetherill, News Chronicle Collection, courtesy of the Thousand Oaks Library.)

75

This early 1967 aerial photograph, taken at 20,000 feet over Thousand Oaks, shows the significant changes since development began. On the left is the Lynn Ranch area, Moorpark Road runs through the center from bottom to top, and Highway 101 is at the very bottom. (Courtesy of Ed Lawrence Collection, Thousand Oaks Library.)

Here is a more recent photograph of the area shown above. The new Oaks Mall is where the Conejo Ranch once was along Hillcrest Drive and Highway 101. The golf course is now a parking lot. It looks almost the same today. (Courtesy of Ed Lawrence Collection, Thousand Oaks Library.)

The Oaks Mall often featured fashion shows to highlight the latest fashion trends for sale in the retail stores. Marilyn Shore Studios ran the productions, using locals who were modeling students in her school. (Courtesy of Roberta Martin.)

Lupe's Mexican restaurant was originally called Lupe's Café and started in a tiny green building; it was founded by Martha Zuniga in 1947. It was named after one of her daughters, who went on to run the place. This was the go-to place for many residents. (Photograph by Sal Bromberger, News Chronicle Collection, courtesy of the Thousand Oaks Library.)

A cook at Lupe's prepares tacos. Lupe's served fresh, homemade, authentic Mexican food to locals and celebrities working on location in the area. (Photograph by Sal Bromberger, News Chronicle Collection, courtesy of the Thousand Oaks Library.)

Pictured here is Rick Lemmo at radio station Lite 97.7 or KMLT, previously known as KNJO —"Conejo." Lemmo became the general manager shortly after Joe Amaturo purchased the station, changed the format, and tried a unique approach. Lemmo, with former KISS FM production and programming guru Ron Shapiro and music director Paul Mahler, hired former top Los Angeles radio talent like Paul Freeman, Bruce Vidal, Mucho Morales, Guy Davis, and syndicated programming from Casey Kashmir. For the first time in history, this area had quality radio and California ratings. Lemmo also had a hand in many of the changes in Thousand Oaks over the years. (Courtesy of the Greater Conejo Valley Chamber of Commerce.)

Evelyn "Ferbie" Simpson had a gift for matching her music students together in small groups to play around town. In front on the left is Joel Moody holding a white Jazzmaster, with Paul Trombetta on the right holding a 1959 Fender Stratocaster. (Local History Collection, courtesy of the Thousand Oak Library.)

Nils Olsen and other early settlers in the area wanted a less treacherous way to get their crops from the Conejo Valley to Port Hueneme or Oxnard. In 1909, the Norwegian families Olsen and Pedersen, and a few others in the Norwegian colony, got together and literally built a road with their own hands through the Olsen ranch; hence the name Norwegian Grade. They used dynamite to blast through the hill and then manpower, horses, and a Fresno Scraper to move the dirt and pave the road on this steep grade. It took them three years to complete. In this photograph, the Norwegian grade is toward the bottom, the McCrea Ranch is on the right with Moorpark Road above, and Highway 23 it at top left. (Courtesy of Ed Lawrence Collection, Thousand Oaks Library.)

Nils Olsen, Ole Nelson, Lars Pedersen, George Hanson, and Ole Anderson were early settlers in the Conejo Valley. Together, they purchased 650 acres and grew barley and wheat. Their land was known as the Norwegian Colony. Here, from left to right, are Dr. Orville Dahl and the three Pedersen brothers: Richard, Peder, and Lawrence. In the early 1960s, the Pedersens' land would become California Lutheran College, with Dr. Dahl serving as the school's first president. (News Chronicle Collection, courtesy of the Thousand Oaks Library.)

California Lutheran College, now University, was founded in 1959. Dr. Dahl, the first president, opted to build a swimming pool first to attract visitors in the hope that they would stay when the school was complete. He met with great success. This is the continuum building housing the library and education department. (Courtesy of Ed Lawrence Collection, Thousand Oaks Library.)

A new breed of cowboys moved their training camp into town when Tom Landry and his Dallas Cowboys football team trained at California Lutheran University from 1963 to 1989. The Rams returned to Southern California in 2016 and will be training on the north campus of the university. (Courtesy of Ed Lawrence Collection, Thousand Oaks Library.)

In 1960–1961, the Conejo Valley suffered a severe drought, and Lake Sherwood almost evaporated completely. In this image, the docks are out of the water and nearby ranches grazed cattle on the lakebeds. A few years later, heavy rains caused an extreme overflow to go over the dam into the Foxfield area, wreaking havoc. (Courtesy of Ed Lawrence Collection, Thousand Oaks Library.)

Prior to the drought in the 1940s and 1950s, Lake Sherwood provided locals with a location to relax and swim. It was not a very populated area back then. Hollywood used it for a number of films. *Robin Hood*, starring Douglas Fairbanks, and *The Adventures of Robin Hood*, starring Errol Flynn, used it as the location for Sherwood Forest, and the name stuck. (Courtesy of Georgan Schmitz.)

The area was considered more remote and had smaller homes dotting the shorelines. It was peaceful and relaxing. Here is a view as development started, and below is a view of the same spot a few years later. As development of Westlake Village continued, it spread to Lake Sherwood. Small homes along the lake became bigger homes, and more homes were built in between the existing ones. Soon, gated communities and celebrities populated the area, which grew into a large luxury community and golf course. (Both, courtesy of Ed Lawrence Collection, Thousand Oaks Library.)

This is Maj. Leigh French and his wife, Elinore. He was 55 and she was 20 when they got married. They owned a ranch in Hidden Valley, where she became known as "the matriarch," as she was a guardian of Hidden Valley and worked hard to keep it from becoming overdeveloped. (Courtesy of Ed Lawrence Collection, Thousand Oaks Library.)

Homes in Hidden Valley were primarily weekend or vacation homes for the rich and/or famous who desired a private spot, although some did make the valley their primary residence. The area offered privacy since there are no sidewalks for people to stroll by and take a peek inside. This is Elinore French's Spanish Colonial home. (Courtesy of Robert Werner.)

Stables were a necessity in Hidden Valley, which was and still is an affluent horse ranch community. Most people had either horses or cattle, and often both, on their ranch for not only enjoyment, but also to help with managing the ranch. This barn sits on the French estate. (Courtesy of Robert Werner.)

Wells are also a necessity in Hidden Valley, as the Hidden Valley Municipal Water District does not supply water, and water is not an abundant resource in this area. The hope is that lack of suitable water will keep developers away. (Courtesy of Robert Werner.)

Gladys Knapp owned 50 acres in Hidden Valley where she bred Thoroughbred horses. She was raised more as a socialite but much preferred quiet country living. Luckily, she loved to drive, so going to Hollywood for parties was not a problem as long as she could come home to the country. As much as she loved her dogs, she did not love their fur in the Rolls Royce she took for her long drives, so she had a separate Rolls for the dogs. (Courtesy of Robert Werner.)

Elinore French was widowed at a young age, but that did not stop her from single-handedly managing the 300-acre ranch her husband left her in Hidden Valley. In addition to the matriarch, she was also known as the "grand dame of the valley" and was passionate and very active in preserving the natural beauty of the area. (Courtesy of Robert Werner.)

This is Deerwood Stock Farm, the first ranch on the right when entering Hidden Valley. It was not only a working farm, it was also a popular spot for Western films to be made. It was owned by J.C. Dellinger and eventually sold to David Murdock, CEO of Dole Corporation, which is headquartered in Westlake Village. (Courtesy of Ed Lawrence Collection, Thousand Oaks Library.)

David Murdock, who seems intent on preserving Hidden Valley, purchased the Deerwood Stock Farm from a corporation with failed development plans due to lack of ground water. He wanted to bring in Metropolitan Water Company, until the neighbors blocked that idea. Murdock later purchased the McMahon Ranch. He kept the front portion the same but converted the back to the Sherwood Country Club, shown here. The Tiger Woods annual charity golf tournament was held here for 15 years. Murdock also bought Burt Sugarman's ranch, where he raised Andalusian horses. (Courtesy of Ed Lawrence Collection, Thousand Oaks Library.)

The Chumash Indians were the first settlers in the Conejo Valley. Charlie Cooke was a local Chumash chief and an open space advocate for protecting Native American sites in Ventura and Los Angeles Counties. Cooke played a large role in the creation of national, state, and local parks, as well as guiding development in the area, something he knew he could not stop, but felt he could steer in a way that would protect the Chumash heritage. (News Chronicle Collection, courtesy of the Thousand Oaks Library.)

Four

WESTLAKE VILLAGE

Pictured is John L. Notter, president of American-Hawaiian Land Company. He is the man who Daniel K. Ludwig, owner of American-Hawaiian Steamship Company, hired to build Westlake Village. Notter brought the vision of the master plan to life. Notter dealt with two different counties that had very different ideas for how things should be handled. Every last detail for a better way of life was carefully thought out, and he hired the best to complete each task. He was the person who came up with the name Westlake Village. He also owns and operates the Westlake Village Inn, Mediterraneo, Stonehaus, Bogie's, and soon, a spa. (Courtesy of John L. Notter.)

Ranchers would move the cattle from one end of the Albertson Ranch to the other. Since Highway 101 went through the ranch, they needed to get them through one of two tunnels in order to safely cross to the other side of the ranch. Here, they are starting to round up the cattle. (Courtesy of Ed Lawrence Collection, Thousand Oaks Library.)

The ranchers are pictured here pushing the cattle into the draw to get them into one of two tunnels that went under Highway 101. This one was at Westlake Boulevard. The tunnels were the only way to safely get the animals from one end of the ranch to the other. (Courtesy of Ed Lawrence Collection, Thousand Oaks Library.)

This image was captured after the cattle had gone under the Highway 101 Westlake overpass into the promenade area. (Courtesy of Ed Lawrence Collection, Thousand Oaks Library.)

Foreman Jack Braden, on the right, is seen after bringing the cattle through the tunnel under Highway 101. This particular herd of longhorn cattle were kept for use in films and televisions shows, such as *Rawhide*. (Courtesy of Ed Lawrence Collection, Thousand Oaks Library.)

Years of planning went into creating the Westlake Village master-planned community. Westlake Village residents were able to select from a wide range of single-family dwellings, townhouses, high-rise view apartments, and estate homes. Great emphasis was placed on preserving the natural beauty of the community throughout in order to maintain a rural, resort-like atmosphere with elaborate recreational facilities. From left to right are Jim Johnson; Gail Frampton, American-Hawaiian Land Company vice president in charge of planning; Phil Cravitz, American-Hawaiian Land Company vice president in charge of engineering; John L. Notter, American-Hawaiian Land Company president; Al Dietch, attorney and Westlake Village general manager; Bob Tatum, American-Hawaiian Land Company marketing director, and unidentified. (Courtesy of John L. Notter.)

American-Hawaiian Land Company, a division of American-Hawaiian Steamship Company, began construction of Westlake Village in 1966 after three years of planning and waiting for approval from two counties. One of its first projects was to move a large oak tree from the planned dam site to its new home on the Westlake Village Inn property. ValleyCrest oversaw the landscaping project, which took over a year to complete in order to protect the tree's roots. (Courtesy of Ed Lawrence Collection, Thousand Oaks Library.)

Work has begun on the creation of the lake and island. Workers dig near what will be the entrance to the island and where Los Angeles and Ventura Counties meet. (Courtesy of Ed Lawrence Collection, Thousand Oaks Library.)

The Old Russell Cemetery, also referred to as the Triunfo Ranch Cemetery, where 29 pioneers from the Conejo Valley were laid to rest, was in use from 1880 to 1926, and then abandoned. With the new development changes in Westlake Village, the American-Hawaiian Land Company went to great lengths to locate family members, identify the remains, and get family permission to save, restore, and relocate the cemetery. In 1969, a total of 29 grave sites were moved to Valley Oaks Memorial Park with help of cemetery president Darwin Dapper, at right. The new location is now part of the Pierce Brothers Westlake Village Memorial Park. Only 11 of the tombstones are still in existence. (Courtesy of John L. Notter.)

Every spring, cowboys would conduct a round-up to brand the new calves. It took place on the northern portion of the Albertson Ranch. Here, cowboy Gene Agdeppa is driving the cattle into the corral. The last round-up took place in 1966, just before development began to turn the ranch into Westlake Village. (Courtesy of Ed Lawrence Collection, Thousand Oaks Library.)

Cowboys from all over liked to participate in the round-ups, as it gave them practice for roping cattle in rodeos. They would come from ranches in Simi Valley, Santa Paula, and Hidden Valley. (Courtesy of Ed Lawrence Collection, Thousand Oaks Library.)

This photograph shows the cowboys separating the calves from their mothers. The cowboys knew exactly which calves to keep in the corral to successfully separate them. (Courtesy of Ed Lawrence Collection, Thousand Oaks Library.)

This is the start of the branding operation. Six cowboys took turns with the roping. One tried to lasso the head, and the other the hind feet, while others did the branding. After 12 calves were branded, they would trade positions. (Courtesy of Ed Lawrence Collection, Thousand Oaks Library.)

The Renaissance Pleasure Faire was begun in 1963 by Ron and Phyllis Patterson. In 1965 and 1966, it was held on the Paramount Ranch near Malibu Canyon. After the 1966 Faire, there were charges of drunkenness, lewd conduct, and possible narcotics. Consequently, Phyllis Patterson obtained permission from the American-Hawaiian Land Company to hold the 1967 Faire on the north ranch portion of their property. Some local residents led a campaign to stop the Faire after the first weekend, and the Ventura County supervisors voted three-to-one to uphold an appeal against the county special use permit for the festivities. Even with a heavy police presence, no one was arrested at the 1967 Faire, and it was determined that the 1966 charges were unsubstantiated, so in 1968, the Faire returned to the Paramount Ranch for decades. (News Chronicle Collection, courtesy of the Thousand Oaks Library.)

Rick Braden (rear, with paddle), son of Albertson Ranch foreman Jack Braden, enjoys rafting with his friend and dog in 1966. This little lake, which only filled up during the rainy season, is now just a creek, located near where Lindero Canyon and Triunfo Canyon Roads meet. Part of the movie *The Adventures of Robin Hood* starring Errol Flynn was filmed at this location. (Courtesy of Ed Lawrence Collection, Thousand Oaks Library.)

Lake Eleanor Dam was originally built as a reliable source of water for cattle. In 1972, after 83 years, officials decided that the reservoir was a hazard, so it was drained, leaving behind this mud. Supervisor John Conlan started receiving calls concerning an environmental disaster about frogs dying by the hundreds, as clearly no one told the frogs the lake was to be drained. Environmentalists asked the firemen to pick up the frogs and put them in the Triunfo Creek. Conlan was not happy about this use of taxpayers' money. Then 12 soldiers appeared, reporting for duty. Picture the mud seen here full of firemen and soldiers carrying frogs to safety. Channel 7 News came out to cover the disaster story, but the crew needed to do several takes because they were laughing too hard. The community was thrilled and praised the men for saving the frogs. (Photograph by Bob Pool, News Chronicle Collection, courtesy of the Thousand Oaks Library.)

Pictured here is traffic-free Highway 101 running through the Albertson Ranch, which became Westlake Village, in 1963. (Courtesy of Ed Lawrence Collection, Thousand Oaks Library.)

The future site of the Albertson Ranch is pictured here, on the Los Angeles and Ventura County line where Rancho Las Virgenes and Rancho El Conejo meet. In 1874, land grant heirs from the De La Guerra family sold part of their land to early settlers John Edwards and Howard Mills, who in turn sold off parcels to other early settlers. Mills defaulted on payments, which led to a sheriff's sale in 1880, when Andrew and Hannibal Russell purchased the land. In 1917, Joe Russell inherited the land, and in 1925 sold a majority of the Russell Ranch to William Randolph Hearst, who then sold it to the Albertsons. In 1963, the Albertson Ranch was sold to the American-Hawaiian Steamship Company, which went on to create the master planned community now known as Westlake Village. (Courtesy of Ed Lawrence Collection, Thousand Oaks Library.)

Even after development started, cattle still grazed on the Russell Ranch. The sign on the left advertises Westlake Village to motorists on Highway 101. The spot where the cows are relaxing eventually became the home of Baxter Medical supplies. (Courtesy of Ed Lawrence Collection, Thousand Oaks Library.)

Pictured are some of the last sheep grazing on the Westlake Village property before development completely took over. Domingo Rivera Poyo, a Basque shepherd, and his dog Moro, tend to the flock as he gazes across Highway 101 at the Westlake Village Inn. When American-Hawaiian Land Company took over the ranch, one of the first employees hired by John L. Notter was a shepherd to tend to the sheep, which helped keep the grass under control. (Courtesy of Ed Lawrence Collection, Thousand Oaks Library.)

This is a view of the former Albertson Ranch, now Westlake Village. The area grew to include the West Lake; numerous neighborhoods full of homes, schools, parks, and shopping, plus a large auto mall and business park; and of course, many people. (Courtesy of Ed Lawrence Collection, Thousand Oaks Library.)

Westlake Village takes shape. The 43-acre master-planned neighborhoods would feature cul-de-sac streets and many homes with views of the lake. Swartz-Linkletter Co., a San Diego development firm headed by Art Linkletter and builder Stan Swartz, was tasked with installing 290 homes along the lake shores. The first 70 homes designed by architect Robert Leitch of Robert Leitch and Associates, Newport Beach, ranged in price from $25,000 to $37,000. Under the supervision of Peter Walker, the environmental and landscape architect for the project, of Suzaki and Walker of San Francisco, the side yards would be turned into pools, parks, and groves to conform to the Westlake concept. (Courtesy of Ed Lawrence Collection, Thousand Oaks Library.)

The Foxmoor neighborhood of Westlake Village was comprised of Mayfair homes, with a total of seven floor plans. The Mayfair homes are known for their creative spatial design characteristics. Foxmoor Hills homes were built on extra-large lots. (Courtesy of Diane Krehbiel-Delson.)

The Westlake Trails neighborhood was designed to be an equestrian's dream estate, with room to house humans and horses on the property and riding trails mere steps away. The framing for one of the first homes is shown here. Originally, the Westlake Trails custom lots ranged in price from $12,950 to $29,500 and were up to two-and-a-half acres in size. (Courtesy of Ed Lawrence Collection, Thousand Oaks Library.)

Here is a shot of where the fake cemetery was in the movie *King Rat*. In this photograph, the beginning of the construction of the dam wall is taking place. (Courtesy of Ed Lawrence Collection, Thousand Oaks Library.)

The Westlake Village Lake Dam was a $3 million project, the most expensive dam built by a private group. The gravity dam was built in 12 sections on 125 acres; it was 700 feet across, three stories high, and 875 feet above sea level. In the late 1960s, concerned residents who did not understand the concept of a gravity dam called for sandbags, but soon learned the benefits of such a design. (Courtesy of the Greater Conejo Valley Chamber of Commerce.)

Ronald Reagan and Daniel K. Ludwig, head of American-Hawaiian Steamship Company, were good friends. At one time, Reagan had a ranch in the Santa Monica Mountains near the new Westlake Village development that Ludwig's company owned, so Ludwig invited Reagan for a visit. Shown here after taking a tour of the Westlake Village Inn are, from left to right, John L. Notter, president of American-Hawaiian Land Company; Governor Reagan; Daniel K. Ludwig; and Dr. Jules Stein, chairman of the board of MCA Inc. Virginia Ludwig ordered 12 copies of this photograph, saying it was the only image she had seen of her husband smiling, as he avoided cameras. (Courtesy of Ed Lawrence Collection, Thousand Oaks Library.)

In this 1977 photograph, Westlake High School is about to be built in the north part of the Albertson Ranch. (Photograph by Bob Chamberlin, News Chronicle Collection, courtesy of the Thousand Oaks Library.)

In the morning, the cows would watch the motorists go by on Highway 101 near the spot that would eventually become the automotive center. (Courtesy of Ed Lawrence Collection, Thousand Oaks Library.)

As part of the development of Westlake Village, American-Hawaiian Land Co. took on the project of building one of the largest and most modern automotive centers in the United States. The automotive center, annexed to the city of Thousand Oaks, required the relocation of Thousand Oaks Boulevard to accommodate access to the center. This photograph shows the point where Thousand Oaks and Westlake Boulevards met after Thousand Oaks Boulevard was realigned and moved north to meet with Westlake Boulevard. The Westlake overpass is visible to the left. (Courtesy of Ed Lawrence Collection, Thousand Oaks Library.)

Courtesy Chevrolet was the first dealership to open in the new auto mall in September 1967. Shown here are American-Hawaiian Land Co. marketing director Bob Tatum (left) and Courtesy Chevrolet owner Sid Hamilton as they check the development progress for the planned 30,000-square-foot installation for new cars and service, designed by architect R.C. Ovale of Los Angeles. Del Friedman Plymouth would also build a 9,000-square-foot facility designed by architect Perry Neuschatz. (Courtesy of Ed Lawrence Collection, Thousand Oaks Library.)

Buick was one of the first six major agencies to join the marketplace. Eventually, many more automotive dealers took advantage of this new location. (Courtesy of Ed Lawrence Collection, Thousand Oaks Library.)

Here is an aerial view of the 78-acre new automotive center, planned by Albert C. Martin & Associates of Los Angeles. The $2.5 million complex of nine automobile agencies is a place where motorists may obtain everything from a new car to complete repairs. A total of 350,000 cubic yards of earth were removed and replaced with non-expansive topping for 65 acres of building sites. (Courtesy of Ed Lawrence Collection, Thousand Oaks Library.)

In this view looking toward Lake Sherwood is the newly built Westlake Boulevard. In August 1966, John L. Notter requested that Decker and Simi Roads be renamed Westlake Boulevard to prevent confusion after his company realigned the roads. (Courtesy of Ed Lawrence Collection, Thousand Oaks Library.)

A few years later, in the same location shown above, is the new Westlake overpass looking southwest. More development is now in place. (Courtesy of Ed Lawrence Collection, Thousand Oaks Library.)

Here is a closer look at a stretch of Westlake Boulevard just west of the Highway 101 Westlake ramp. (Courtesy of Diane Kriehbal-Delson.)

Signs of change are apparent as workers rearrange the letters on the highway sign to alert drivers that Decker Road has become Westlake Boulevard. (News Chronicle Collection, courtesy of the Thousand Oaks Library.)

The lake and the island with homes are complete, as are the surrounding neighborhoods. The bridge connecting to the island is on the county line, hence the street name, LaVenta, a made-up name representing Los Angeles and Ventura Counties. Entering the island, LaVenta is actually a split street and split bridge with space in between, as each side lives in a different county, and the counties would not cooperate to combine efforts. More than half of the homes on the island are in Ventura County, and the others are in Los Angeles County. (Courtesy of Ed Lawrence Collection, Thousand Oaks Library.)

Fun Ranch was designed to teach people about farm animals. There were chickens, turkeys, lambs, cows, goats, rabbits, and pigs in the petting zoo. There were also hay rides and cowboys demonstrating roping and riding. Knowing that families would be making the drive out to the country, the sales office gave out free Fun Ranch tickets so children could enjoy the park after accompanying their parents through the model homes built by Lee-Lasky and Shattuck-McHone in First Neighborhood, or "the Park." (Courtesy of Ed Lawrence Collection, Thousand Oaks Library.)

In 1968, people interested in life in Westlake Village could board touring boats for a ride around the new Westlake Village Lake. Sailboat races and people picnicking on the grassy shore were common activities. Notice that the left side of the lake, now known as "the fingers," is not built out with homes yet. (Courtesy of the Greater Conejo Valley Chamber of Commerce.)

Westlake Village Lake is one of the largest man-made lakes ever created by a private developer. It includes an island three-fourths of a mile long and 900 feet wide within the 150-surface-acre lake, which is full of homes with waterfront sites. In addition, several hundred units were built on the shores of the lake. Most of the homes on the lake and inshore homes along the fingers of the lake have private boat docks, such as those pictured here. (Courtesy of the Greater Conejo Valley Chamber of Commerce.)

The Landing is a small business complex right on the Westlake Village Lake's shore. It is a combination of retail shops, restaurants, office space, and service industry suites. The upstairs offices in this picture were the original American-Hawaiian Land Company offices. Boccaccio's, the new restaurant overlooking the lake at Westlake, featuring Italian and continental cuisine, is the first privately owned commercial operation of its type within Westlake Village proper. Boccaccio's 2,500-square-feet structure was designed by architect William Rudolph and has seating for 200 patrons inside and on the patio overlooking the lake. The Landing provides parking for 300 cars. (Courtesy of the Greater Conejo Valley Chamber of Commerce.)

The Westlake Village Yacht Club is located at the Landing just off Lindero Canyon Road. Founded March 11, 1969, it originally housed the sales office for the area and provided boat tours for those interested in purchasing a home on the lake's island. The club is now member owned and operated, and while most members live on or near the lake, it is not a requirement for membership, nor is owning a boat. The club has several fleets of its own, including sailboats, electric boats, and kayaks, and offers lessons, races, and fun group activities. (Courtesy of the Greater Conejo Valley Chamber of Commerce.)

The lake is a highlight of the area. It offers sailing, electric boating, and kayaking. The lake was specifically designed for ideal winds. There are fish in the lake, but only catch-and-release fishing is allowed. Many residents also enjoy walking, running, or biking around the lake or picnicking on the shore, something that can be done year-round with the Mediterranean climate of this area. While most of the lake residents have their own boat dock, there are also docks available for those not living directly on the lake. (Both, courtesy of the Greater Conejo Valley Chamber of Commerce.)

Founded in 1968, the Westlake Juniors Women's Club is dedicated to improving the lives of others through volunteer service. The women organize fundraisers to support local nonprofits focused on families, women, and children, and provide hands-on support throughout the year. Here, the Westlake Juniors Women's Club participates in the 1971 Conejo Valley Days Parade. The organization is still going strong as it involves, ignites, and inspires members and the community by actively fundraising and supporting local groups such as Cancer Support Community, YMCA, Many Mansions, and free mammograms for the Conejo Free Clinic, plus feeding the hungry and delivering Meals On Wheels. At the same time, the club encourages the growth of its own members in friendship, education, and personal growth. (Local History Collection, courtesy of the Thousand Oaks Library.)

In 1967, not only did the Westlake Golf Course open for business, it also hosted its first celebrity golf tournament for muscular dystrophy. Shown here from left to right are professional golfer Dave Stockton, actress/comedienne and local resident Donna Jean Young, actor Jack Lemmon, and manager of the Westlake Village Golf Course Clint Airey. Being not only a new course but a new community, the celebrity golf tournament, initially hosted by actor William Demarest, and then actor Tim Conway, helped get the word out about this great course. In 1973, the tournament moved to the North Ranch Country Club. For nearly 20 years, the tournament supported the Cerebral Palsy/Spastic Children's Foundation, which not only resulted in money being raised, but also a land donation from Prudential Insurance Co., and additional grants for apartments for those stricken with the disease. (Courtesy of Ed Lawrence Collection, Thousand Oaks Library.)

The Westlake Golf Course, designed by Ted Robinson, was meant to be a challenging course for all levels, with three-, four-, and five-par holes. The tree-lined course has a lake for beauty and, at times, aggravation for certain golfers because seven of the holes are affected by water. The public course was originally lit at night; however, a shortage of available power pulled the plug on the lights. In the early 1970s, tons of celebrities came out to play on a regular basis to get away from the hustle and bustle of Los Angeles and enjoy a little privacy in the fresh air. Once homes were complete and residents settled in, the course became more of a regulars' club. The juniors' club was very popular, with many kids going on to play in college; a few went on the touring circuit. (Courtesy of the Greater Conejo Valley Chamber of Commerce.)

White doves, the traditional symbol of peace, were used to help the community get into the Easter spirit in 1967. As part of Westlake Village's arts and crafts show, the live doves, housed in six-foot-high cages, surrounded the artwork display area, where 49 artists participated in a competition. (Courtesy of Ed Lawrence Collection, Thousand Oaks Library.)

Jim "Red" Phillips celebrates the completion of the Westlake Swimming Pool. Phillips was drafted by the Los Angeles Rams and spent seven years with the team until he was traded to the Vikings. He joined the Westlake Village developers' team as head of the recreation facilities, coordinating indoor and outdoor programs for residents, and served as the manager of the newly formed Westlake Park Community Association during the off-season. (News Chronicle Collection, courtesy of the Thousand Oaks Library.)

Fourth of July celebrations are still quite festive in Westlake Village. This is a photograph from the 1968 parade in First Neighborhood, with children riding their decorated bikes, waving flags, carrying banners to represent their street, and showing off their patriotic creations, like the Liberty Bell that is being carried by a group of children at center. Children also dressed in Fourth of July–themed costumes, road their horses or in trucks, and then enjoyed a picnic and fun games in the park. (Courtesy of Ed Lawrence Collection, Thousand Oaks Library.)

In 1967, Bill and JoAnn Postel and Nancy Turrill founded the Foxfield Riding School—a place that they quite literally built with their own hands. Located at the base of the Lake Sherwood Dam, Foxfield offers horse-riding classes to all levels of students. Some students have gone on to be Olympians and world champions. Many students have won awards in various competitions and shows. (Photograph by Ed Lawrence, courtesy of Diane Krehbiel-Delson.)

Foxfield Riding School does not have staff groomers, so students must learn to groom the horses themselves. Here, Ingrid Krehbiel grooms Charro while her then husband, David, plays "stable bum," as his T-shirt confirms. Charro was one of the horses usually ridden by a Postel family member to lead the Foxfield Drill Team. Many considered Ingrid the heart of Westlake Village, with her popularity at Foxfield and as the face of Erika's Bake Shop. (Courtesy of Diane Krehbiel-Delson.)

In addition to lessons at the riding academy, Foxfield sponsors events such as rated and unrated horse shows and jumping derbies. They also pride themselves on their mentor program, in which learning is passed along through members and instructors, building community and good sportsmanship. They also have a lot of fun with holidays throughout the year and create fun and games around each theme. Ingrid Krehbiel, shown here, was an accomplished equestrian. Her horse Charro was a wire horse, with all commands done simply by moving a wire. Charro even competed at Madison Square Garden. (Both photographs by Ed Lawrence, courtesy of Diane Krehbiel-Delson.)

The Burroughs Corporation, a Detroit-based business equipment manufacturer, started with the adding machine and eventually became one of the largest producers of mainframe computers. It was the first company to open a major facility and provide jobs in the new Westlake Village industrial center No. 3, where the business primarily made storage and communications equipment. The company spent approximately $22 million to build the plant on a 30-acre site just north of the golf course. Its goal was to employ 2,000 people in 1968 and grow to over 3,000 people in the early 1970s, when the entire facility would be complete. In 1985, the company closed this plant, which employed nearly 600 people. (Courtesy of Ed Lawrence Collection, Thousand Oaks Library.)

Cosmetic company JAFRA was founded in 1956 by Jan and Frank Day. The company name is a combination of the founders' first names. They started in their Malibu home with their signature Royal Jelly product. In 1978, they broke ground for a new facility in Westlake Village and, in 1980, celebrated JAFRA opening its doors on Townsgate Road, where its worldwide headquarters and research and development laboratories still thrive. Shown here from left to right are Jan, Frank, sales consultant Darlene Jacobson, and Janet Gray-Flores, who joined the company in 1970 and is still going strong. (Courtesy of Janet Gray-Flores.)

Pictured above in 1963, what was once a bare field has become a national sensation in the world of unique shopping experiences now known as the Promenade at Westlake Village. In the late 1990s, Caruso Affiliated worked with locals to design a new experience and create a destination for residents looking for shopping and dining nearby. In the process, the company broke down traditional mall design expectations and created a stunning compound. Now, people from all over the Conejo Valley and beyond come here to enjoy the shopping, dining, specialty services, and a luxury movie theater with reclining seats and personal waitstaff. (Both, courtesy of Ed Lawrence Collection, Thousand Oaks Library.)

Dole Food Company is one of the largest employers in Westlake Village. The company is a visible sight at many community functions, sharing its healthy products. Passionate about nutrition, David Murdock created the Foundation of the Dole Nutrition Institute to foster more research for healthy living and longevity and educate the public about better ways to care for one's body. (Courtesy of the Greater Conejo Valley Chamber of Commerce.)

Erika's Bake Shop was a favorite for locals and tourists. Whether coming in to get a treat after school, a celebration cake, a gift, or cure a pregnancy craving, customers were also treated to a gorgeous smile from Ingrid Krehbiel, who managed the bakery. While not actually the real Erika, as some thought, Ingrid truly was "Erika" to her many fans. Dieterich Heinzelmann opened the bakery in 1973 in the Westlake Plaza Shopping Center and served unique creations until rents rose and the bakery closed in July 1995. Blockbuster Video occupied the space after the bakery closed. (Courtesy of Diane Krehbiel-Delson.)

This is Dixie Vollmer of the Plug Nickel Restaurant and catering service, which was located at 717 Lakefield Road in a small industrial park. It was a popular meeting place, especially for the old-timers in the area who appreciated the plain, good food, well-managed restaurant, and hospitality that Dixie offered. Dixie opened the restaurant in 1975, and in 2009, her daughter Valerie took the reins until 2012, when the restaurant changed hands. (Courtesy of the Greater Conejo Valley Chamber of Commerce.)

Although the location is excellent and, one day, would overlook the lake, the ridge was very rocky, so it was decided that a rock quarry and crushing plant were needed. The rock would be crushed and used in other parts of the development. It also included facilities to manufacture asphalt and concrete for use in the other construction projects in the area. The plant employed 20 to 30 men. Given the multiple benefits to the new community, the Los Angeles County Planning Commission had no problem approving a zone change, allowing the rock plant to be built. Today, structures such as this line the ridge. (Courtesy of the Greater Conejo Valley Chamber of Commerce.)

Being a new city, there were often many accomplishments, new businesses, and new advances to celebrate. Shown here is the ribbon-cutting ceremony for the Lindero Canyon Bridge connecting Lindero Canyon and Triunfo Roads near the Westlake Lake Dam. (Courtesy of the Greater Conejo Valley Chamber of Commerce.)

Walking around Westlake Village Lake, one is treated to peaceful and serene views such as this. (Courtesy of the Greater Conejo Valley Chamber of Commerce.)

Where cattle used to graze is now the Hyatt Hotel, formerly the Westlake Plaza Hotel. It was also the last part of the area that Daniel Ludwig owned. He sold most of his land, and the Westlake Plaza Hotel was built for him. He had never seen it, so photographer Ed Lawrence and the hotel manager made a video for him. (Courtesy of Ed Lawrence Collection, Thousand Oaks Library.)

Movie companies were always on location at the Russell Ranch, so no one was allowed to roam the area, but Donna Fargo helped get permission for Ed Lawrence to take photographs for the Conejo Valley Days program in 1962. This image of the Lone Oak, with Russell Ranch buildings in the foreground, was taken from atop Pork Chop Hill, the same place where the movie by this name, starring Gregory Peck, was filmed. Ed Lawrence waited three hours to get the photograph just right, and in return, he presented a copy to the family, who was so pleased with his work, they gave him free reign of the property to take any pictures he wanted—he just needed to show them the proofs. (Courtesy of Ed Lawrence Collection, Thousand Oaks Library.)

The lone oak at Westlake Boulevard and Triunfo Canyon Road, on the old Albertson Ranch, is the center point of this 1967 photograph of Westlake Village under construction. The Westlake Village Lake and First Neighborhood are in the background to the right. (Courtesy of Ed Lawrence Collection, Thousand Oaks Library.)

Lawrence would climb Pork Chop Hill several more times over the years to document the changes. He went in 1966, when the development of Westlake Village was just being established, and again in 1970, shown here. The Lone Oak, so named because it sat in the field all by itself, is visible at center, and the Westlake Lake has been created. (Courtesy of Ed Lawrence Collection, Thousand Oaks Library.)

This photograph was taken in 1983 from the same spot on Pork Chop Hill, but this time, Lawrence drove up the hill rather than climbed, and had to ask permission from the homeowner to take the picture from her backyard. The Lone Oak is still visible, but sadly, the tree got sick and was removed in 2011. (Courtesy of Ed Lawrence Collection, Thousand Oaks Library.)

Discover Thousands of Local History Books Featuring Millions of Vintage Images

Arcadia Publishing, the leading local history publisher in the United States, is committed to making history accessible and meaningful through publishing books that celebrate and preserve the heritage of America's people and places.

Find more books like this at
www.arcadiapublishing.com

Search for your hometown history, your old stomping grounds, and even your favorite sports team.

Consistent with our mission to preserve history on a local level, this book was printed in South Carolina on American-made paper and manufactured entirely in the United States. Products carrying the accredited Forest Stewardship Council (FSC) label are printed on 100 percent FSC-certified paper.

MADE IN THE USA